ART FOR KIDS

LOU LAWRENCE

Art displays imagination and feeling and these traits are apparent in children's artwork. Many can hold a crayon, scribble shapes, hum, and dance as early as age one.

Art is very important since studies have shown that young people who work with art do better in school. It has been proven that art helps develop language and motor skills, and that art education even helps in

the development of problem solving and decision-making.

However, art education in schools has declined for several decades. The reasons for the decline are tight school budgets, more emphasis on test scores, and the *No Child Left Behind* program does not focus on art.

Educators apparently believe that art education is nice but not necessary. Children who missed art education in the 1970's and 1980's are now adults and may not even understand the need for art.

Hopefully, parents today appreciate the benefits of art education for their children.

Some of these benefits are:

· Motor skills: Holding and using a crayon or paintbrush improves motor skills.

· Language: Talking about art teaches new words and new shapes and colors.

· Decision-making: Creating pictures and making art figures aids in problem solving and decision-making.

Children show imagination and skill at a young age in their attempts to express themselves. Many begin by drawing figures like cats, dogs, and the sky with a

sun. The sun usually has rays that go to the ground.

Children's Art

 Children learn more from pictures than words. The saying: *A picture is worth a thousand words* is especially true for young people.

 Art is the expression of feelings and passion, and artists talk to the observers with their artwork.

When an artist paints or sculpts an object, he or she is showing their feelings about the subject. Michelangelo, the famous artist, painted the ceiling of the Sistine Chapel in 1508 and he was expressing his thinking of the Book of Genesis in the Bible.

Creation of Adam by Michelangelo

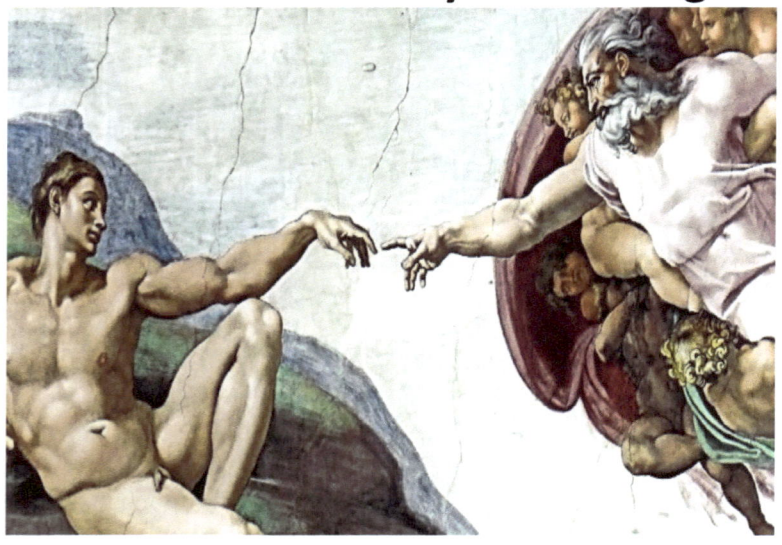

Most people think of paintings when they consider art but there are nine types of art.

ART FORMS

PAINTINGS
SCULPTURES
MUSIC
DANCE
WRITING
POETRY
THEATER
ARCHICTURE
PHOTOGRAPHY

Art goes back thousands of years and the oldest art forms are sculptures and paintings.

AGE OF ART FORMS

ART FORM	AGE IN YEARS
SCULPTURE	40,000
PAINTING	35,000
MUSIC	35,000
DANCE	35,000
ARCHITECTURE	12,000
WRITING	5,000
POETRY	2,700
THEATER	2,500
PHOTOGRAPHY	177

Art began in the Stone Age and the Neanderthals lived during that time. The name came from the Neander area in Germany where bone fossils were found in 1856. The Neanderthals are related to modern-man since 95% of their DNA is the same.

Ice covered the earth for much of the Stone Age and the people lived in caves to get protection from the ice, hence the name *caveman.*

The Neanderthals made paintings and sclptures in their cave homes so the Neanderthals were the first artists. You will find this hard to believe when you look at the next picture.

Neanderthal

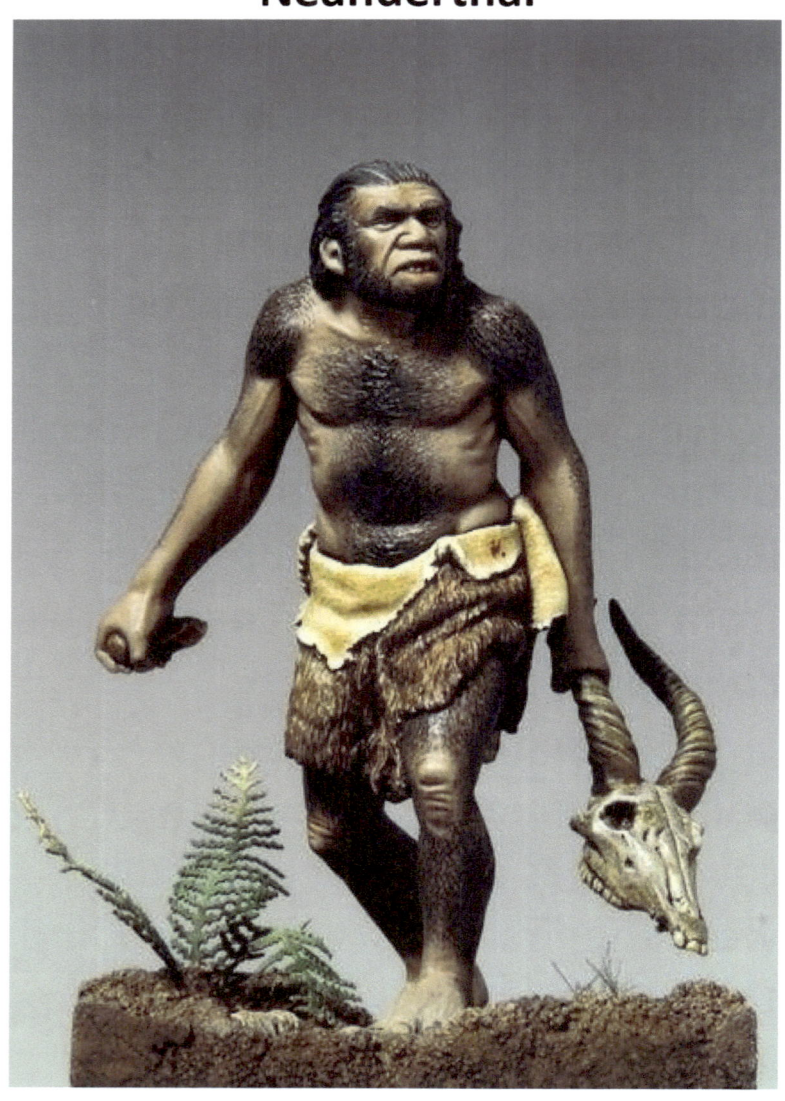

Neanderthal Paintings

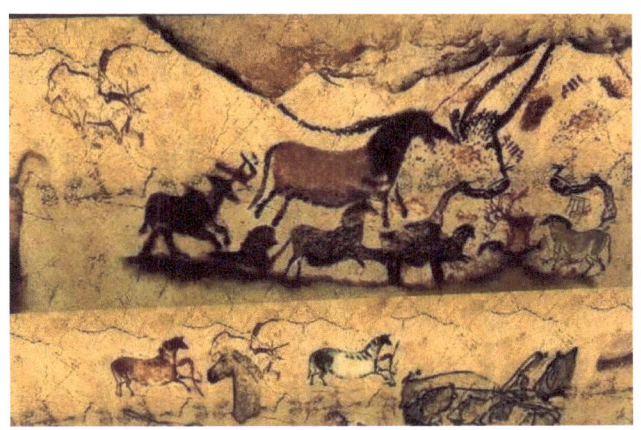

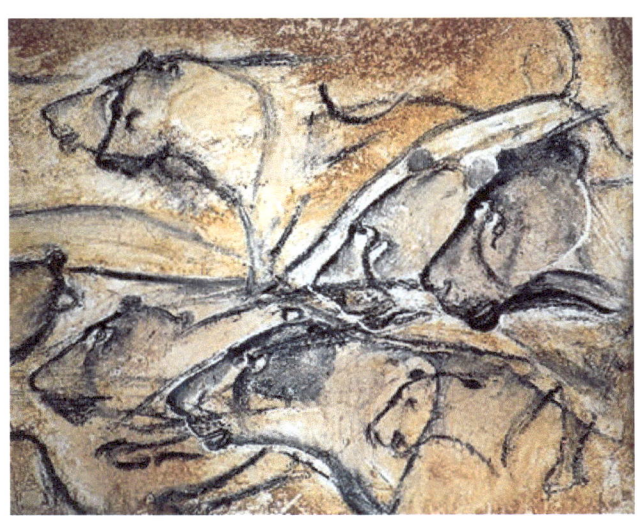

Neanderthal Sculptures

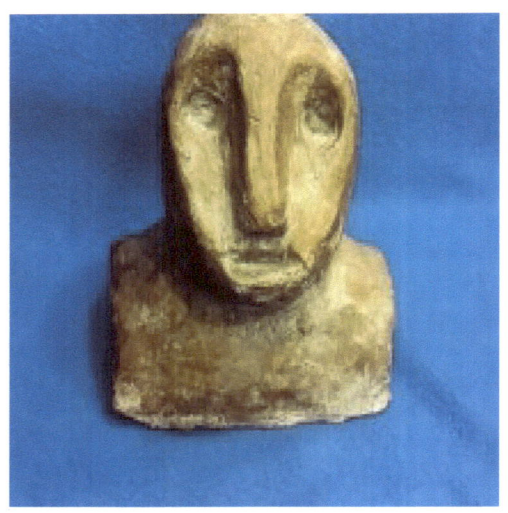

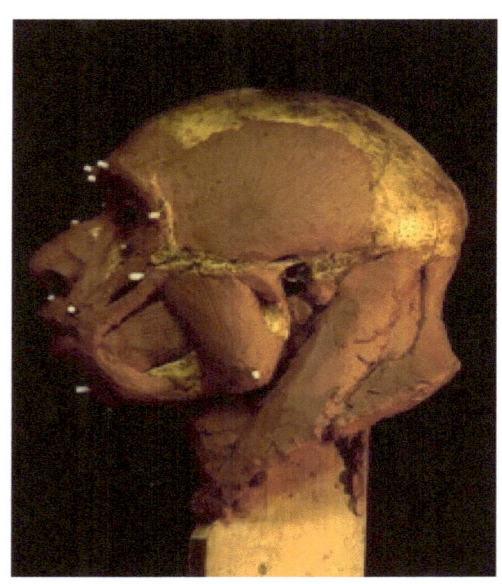

History is a record of the past and when youngsters study art, they learn about history. When they see art of prior years, they see pictures of life in the old days.

Prehistoric Painting

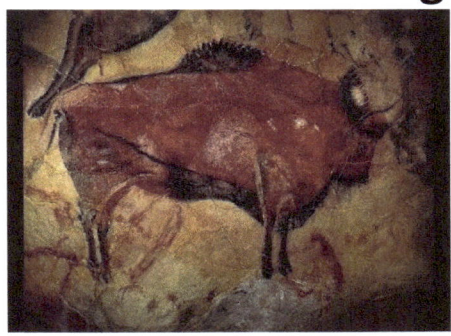

Prehistoric Sculpture

Greek Painting 500 BC

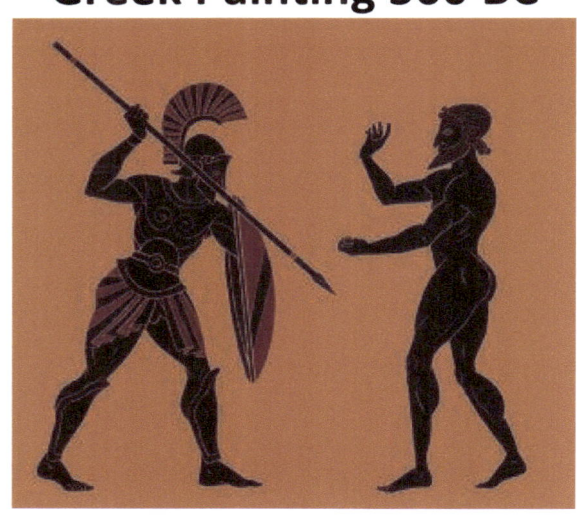

The Discus Thrower 450 BC

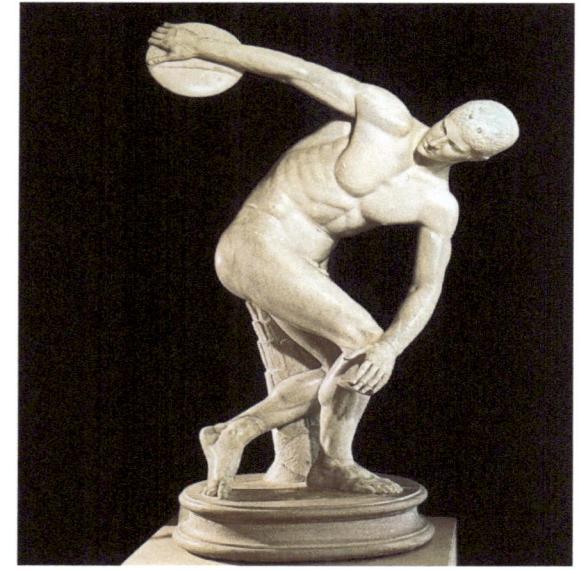

Henry VIII 1400

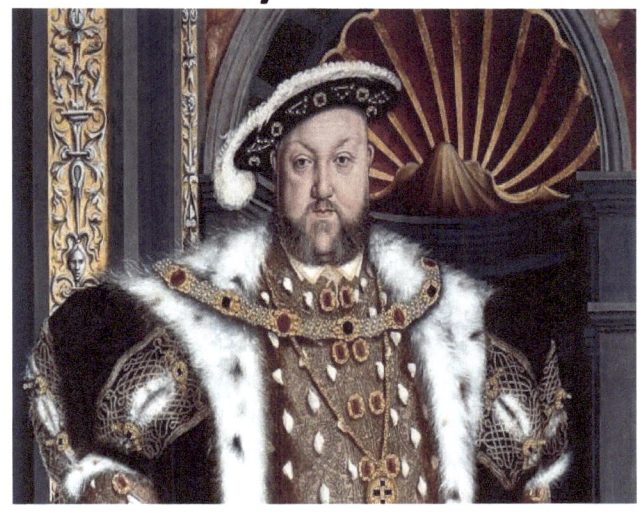

David by Michelangelo 1501

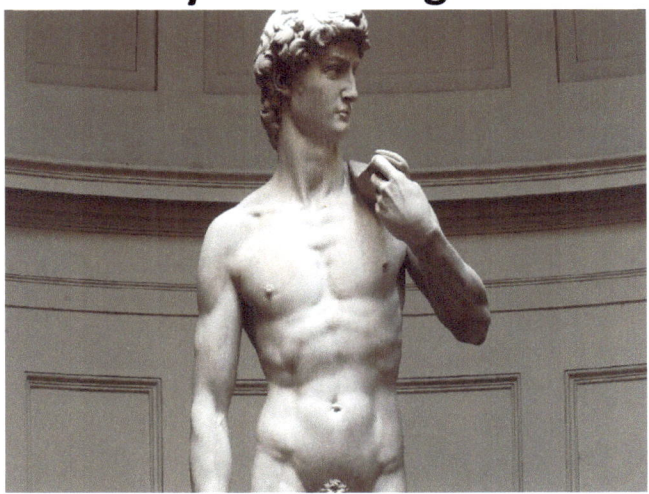

Wine Glass by Vermeer 1659

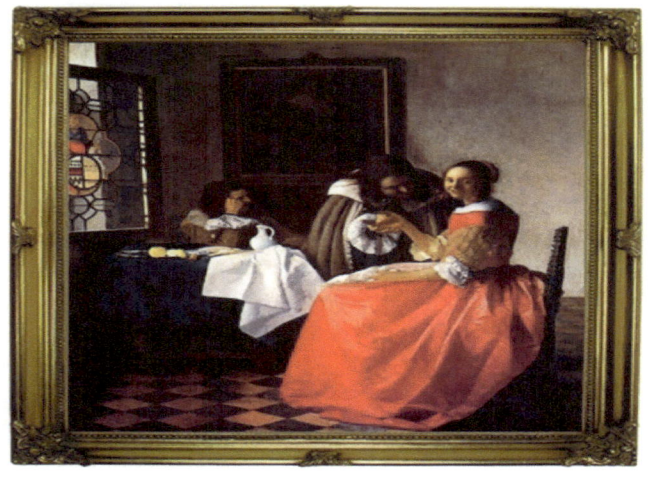

Folies-Bergere by Manet 1892

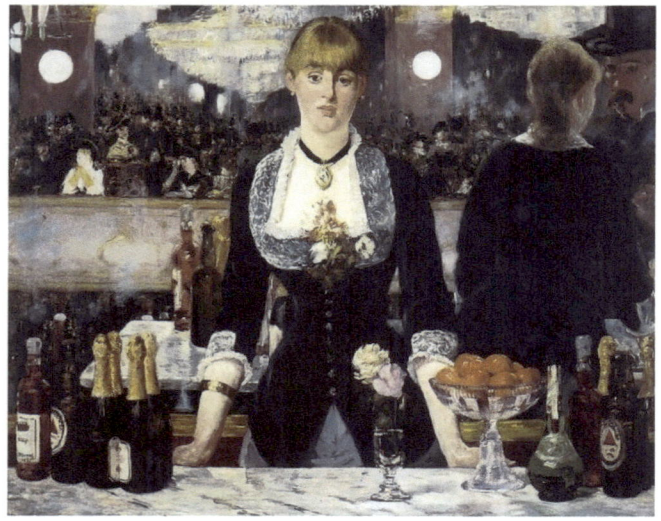

MOST FAMOUS ARTISTS

Leonardo da Vinci

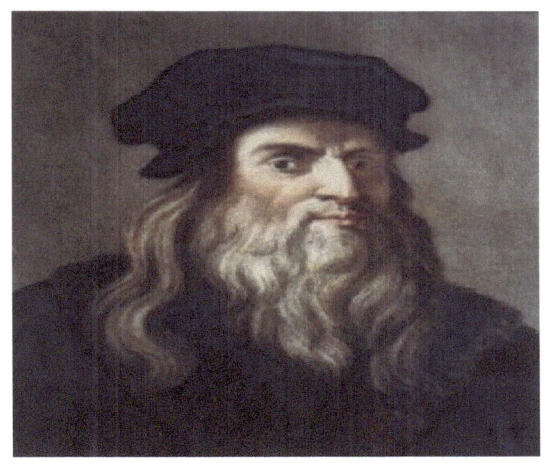

Vincent van Gogh

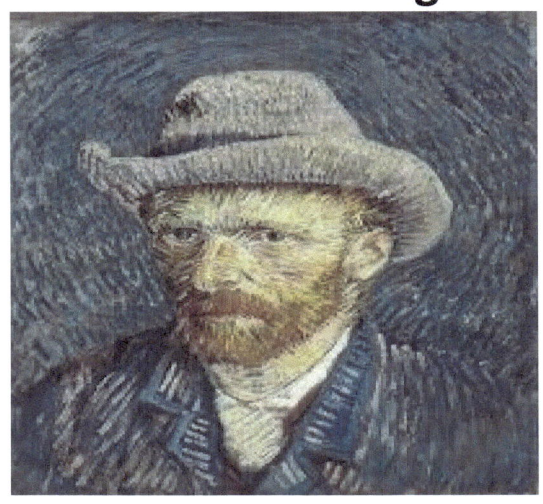

Rembrandt

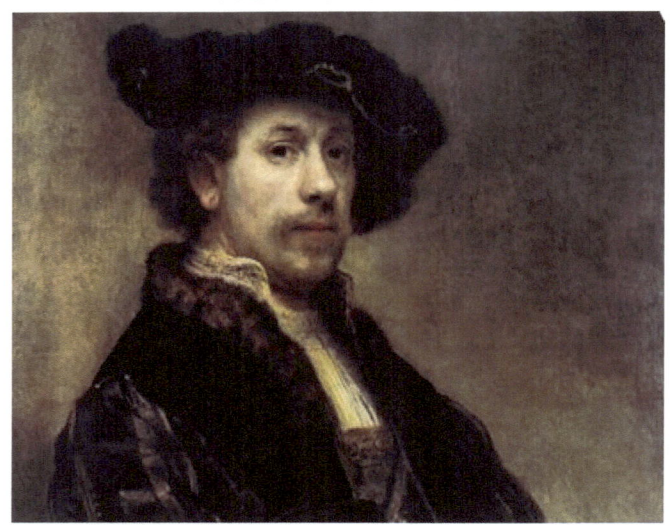

Michelangelo

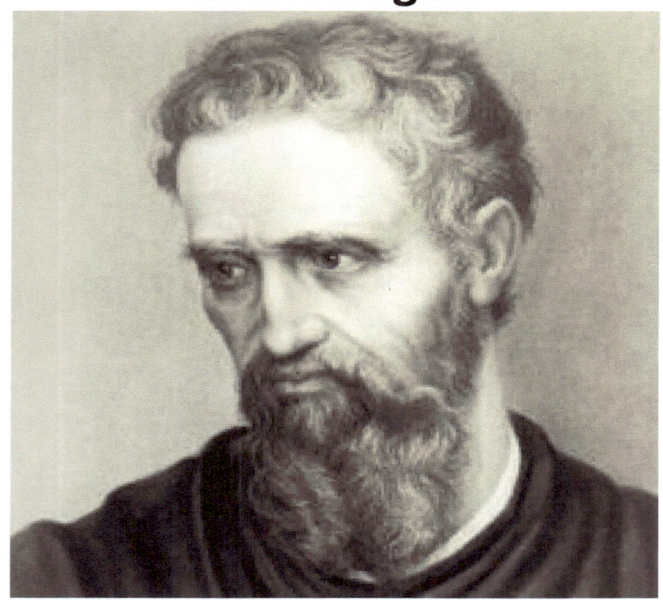

Claude Monet

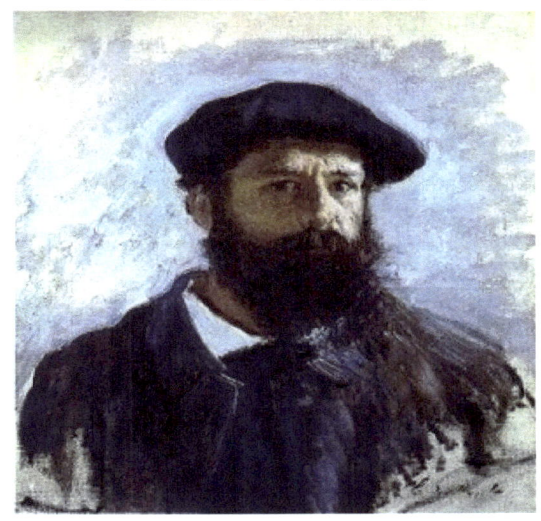

Rodin

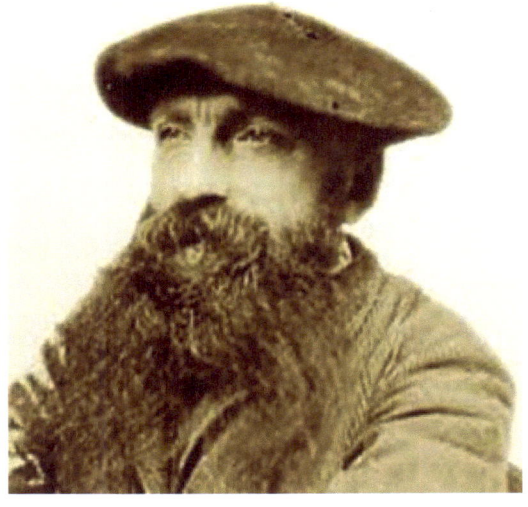

Raphael

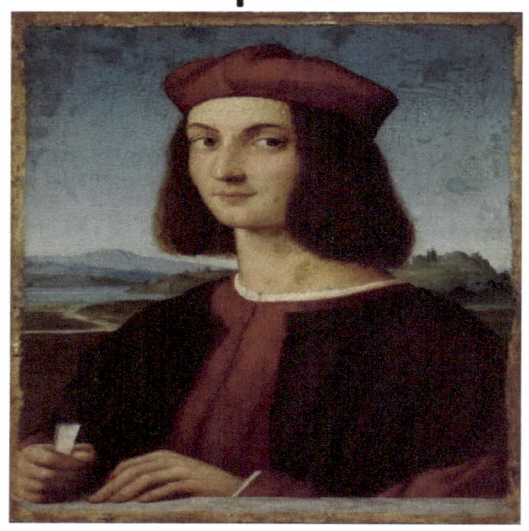

Renoir

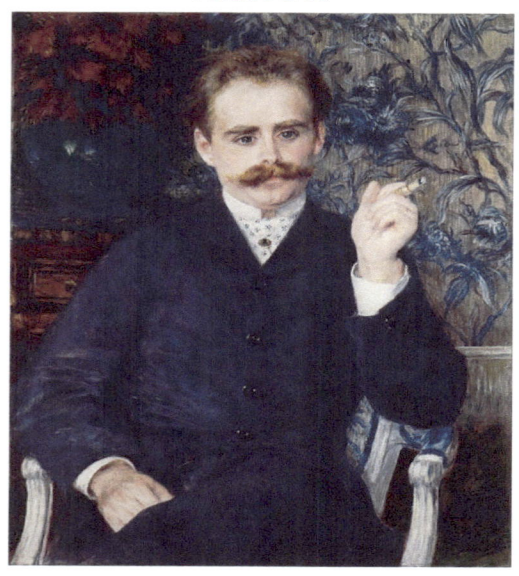

Pablo Picasso

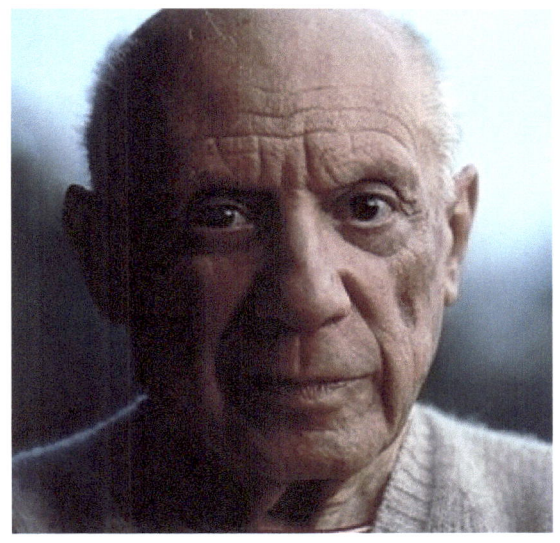

Andy Warhol

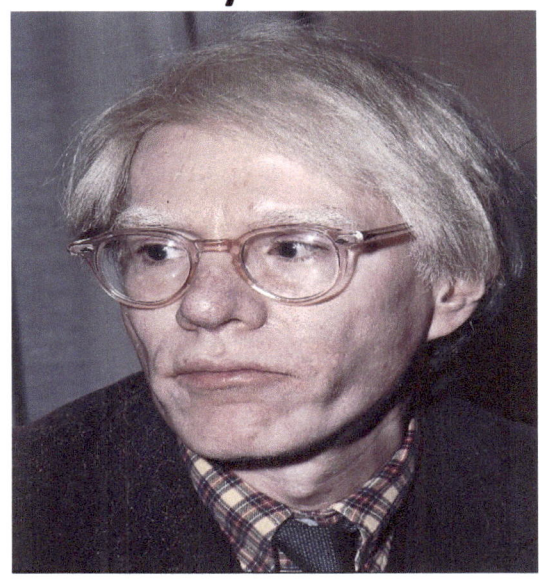

FAMOUS PAINTINGS

Mona Lisa by Leonardo da Vinci

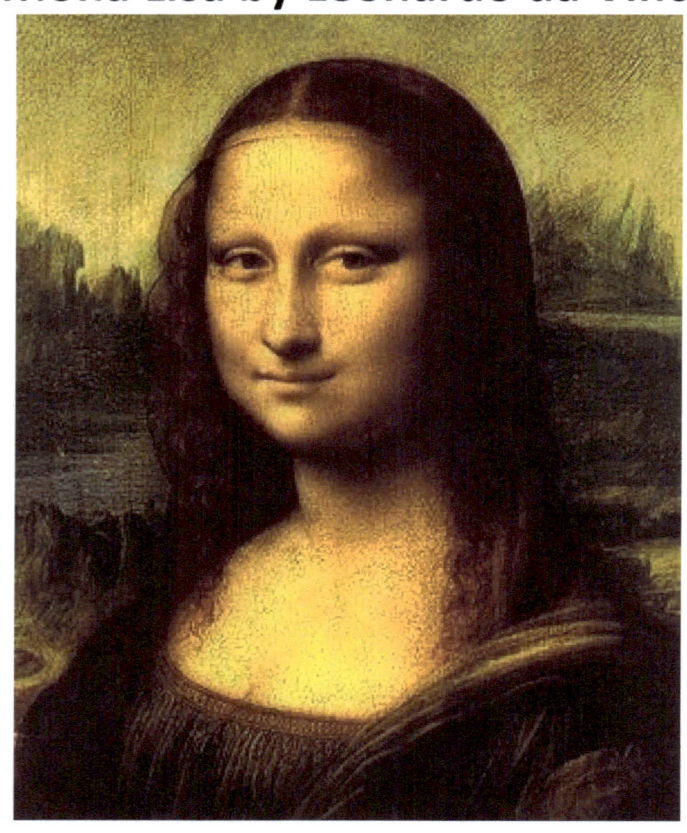

Starry Night by Vincent van Gogh

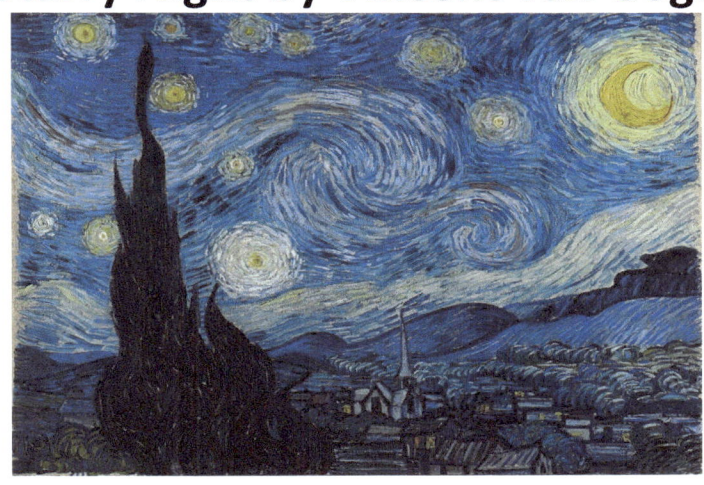

American Gothic by Grant Wood

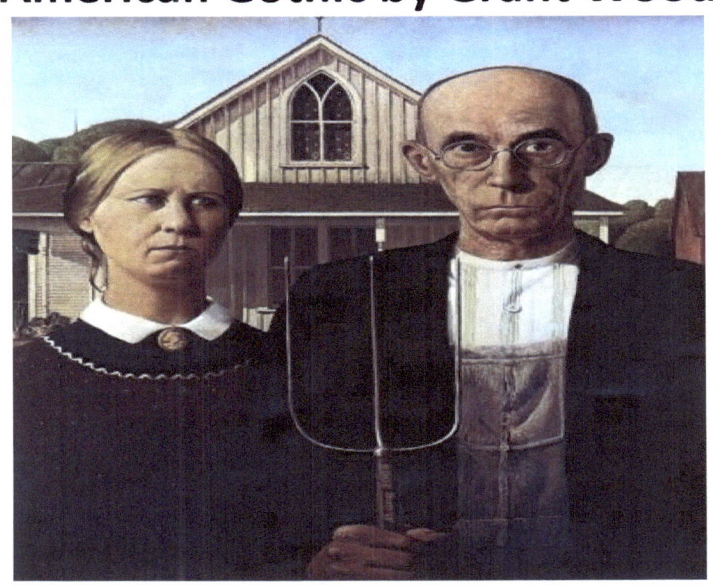

Night Watch by Rembrandt

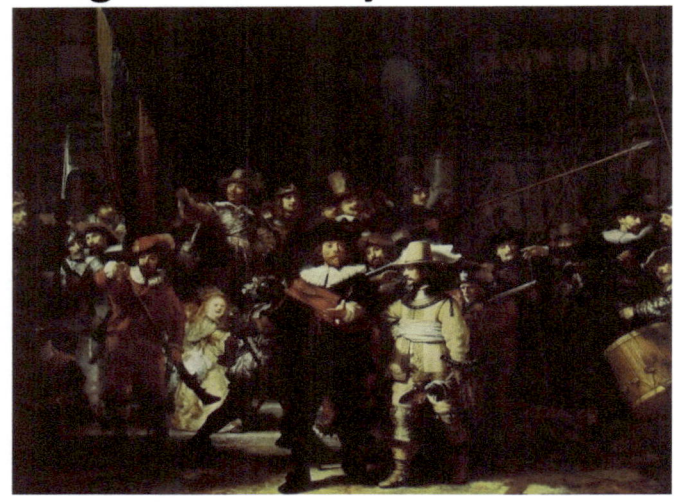

Card Players by Paul Cezanne

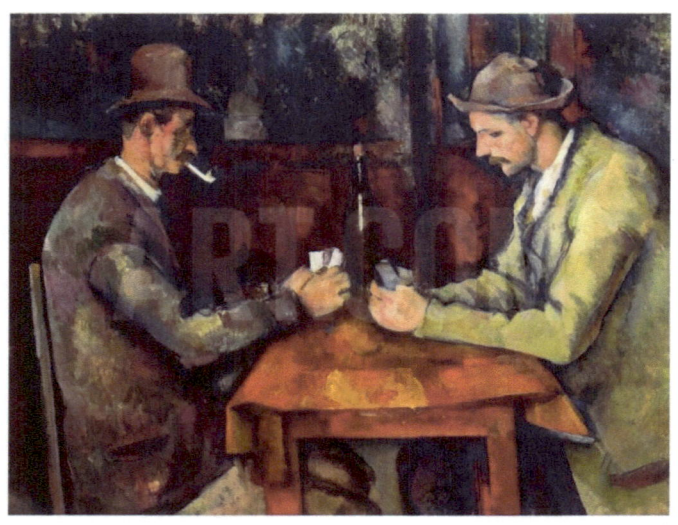

A sculpture is a three-dimensional figure carved from wood or stone in ancient times. Sculptures were made of metal castings in later centuries.

Small rock forms that appeared to be man-made have been found that date back 200,000 years, but the oldest sculpture found that appears realistic is 40,000 years old. The twelve-inch ivory carving was found in a cave in Germany in 1939. This prehistoric sculpture was called the *Lion Man* since it has the head of a lion on the man figure.

The famous Stonehenge ring of stones found in England is 5000 years old.

The Lion Man

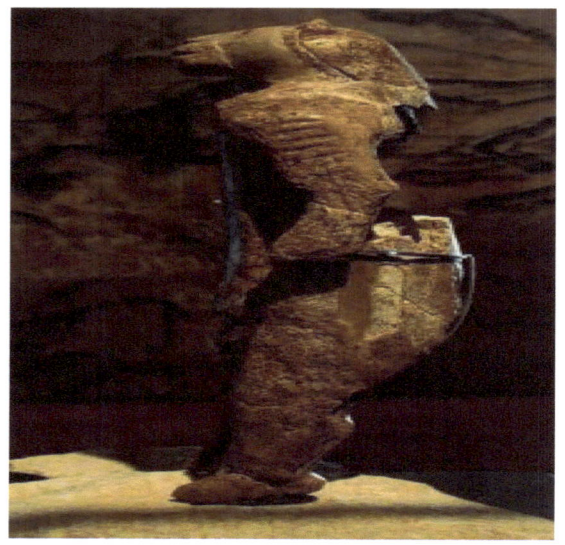

Stonehenge

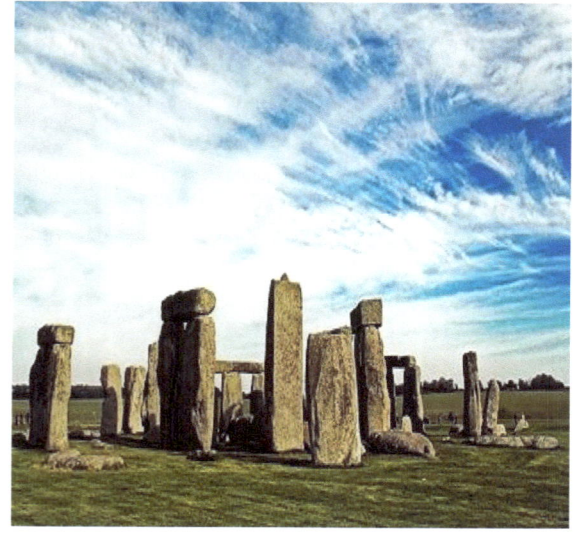

FAMOUS SCULPTURES

David by Michelangelo

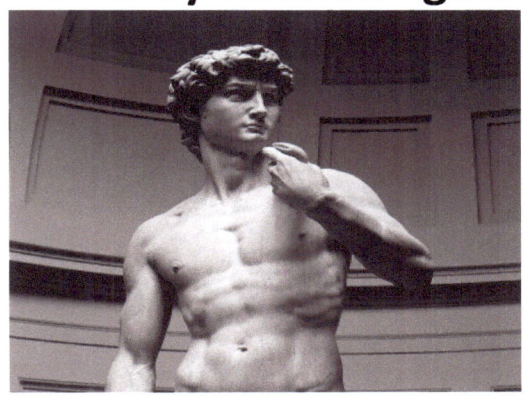

The Thinker by Rodin

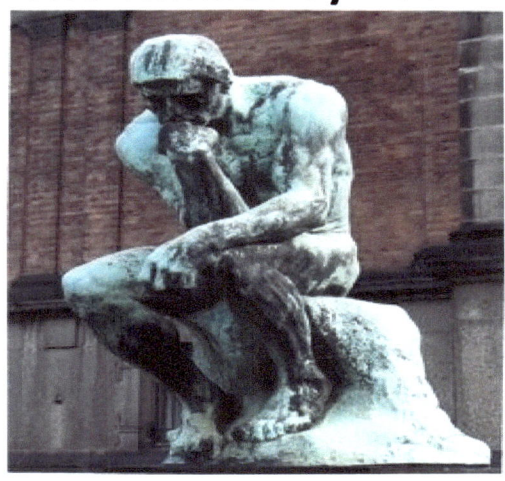

Venus de Milo by Alexandros

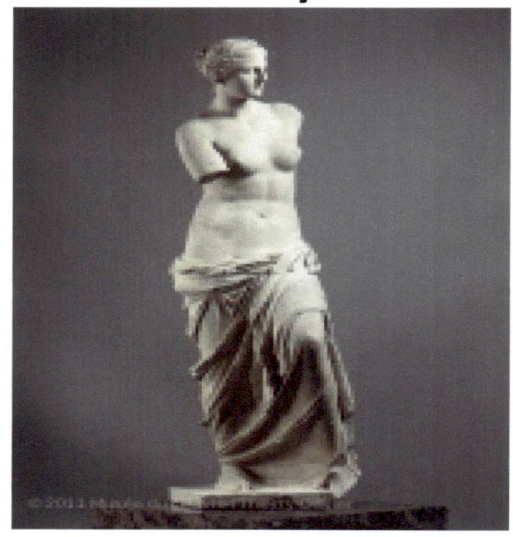

Pieta by Michelangelo

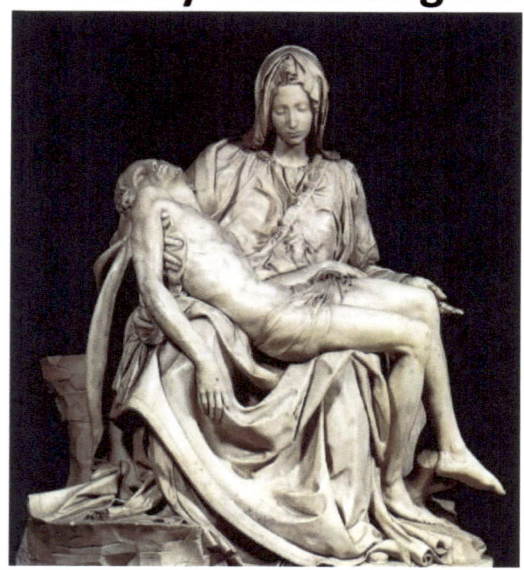

Music and dance also started in prehistoric times. There are cave paintings that show people dancing that date back 35,000 years, and flutes made from bones are 35,000 years old.

Prehistoric painting

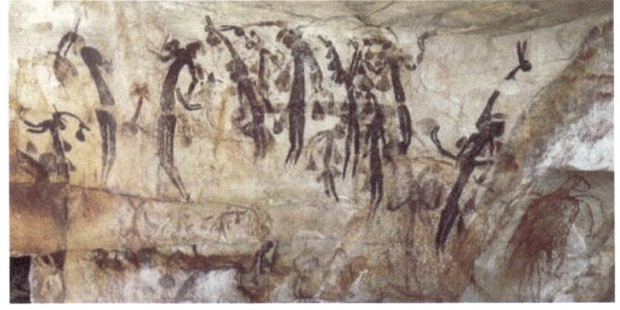

Prehistoric Flutes

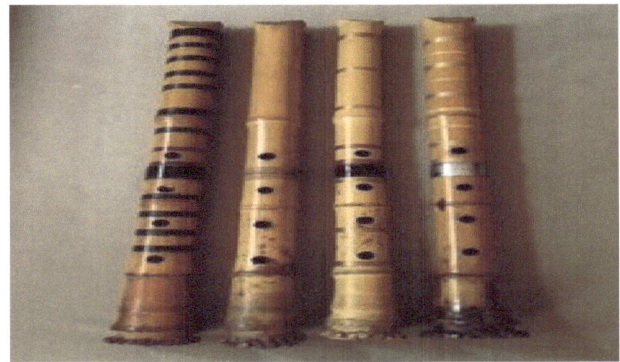

Architecture is the art of designing and creating buildings. Ancient people built mud brick buildings about 12,000 years ago, and the Egyptians built pyramids 4700 years ago. Greece is noted for architecture and the famous temple, the Parthenon, was built in 450 BC.

Prehistoric Mud Buildings

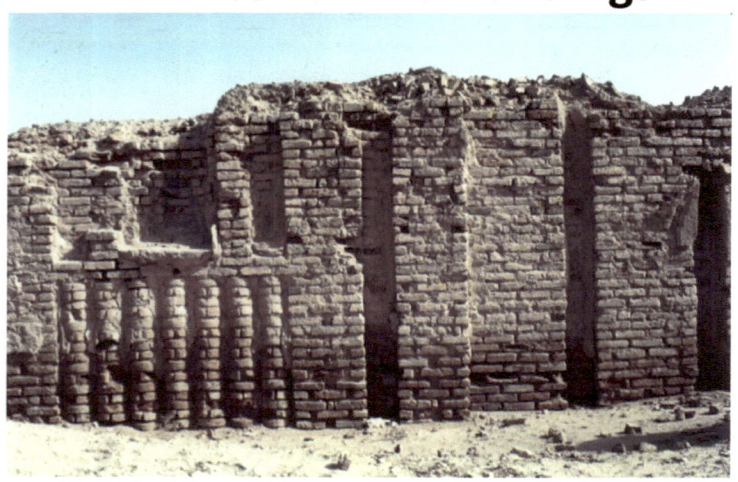

Egyptian Pyramid

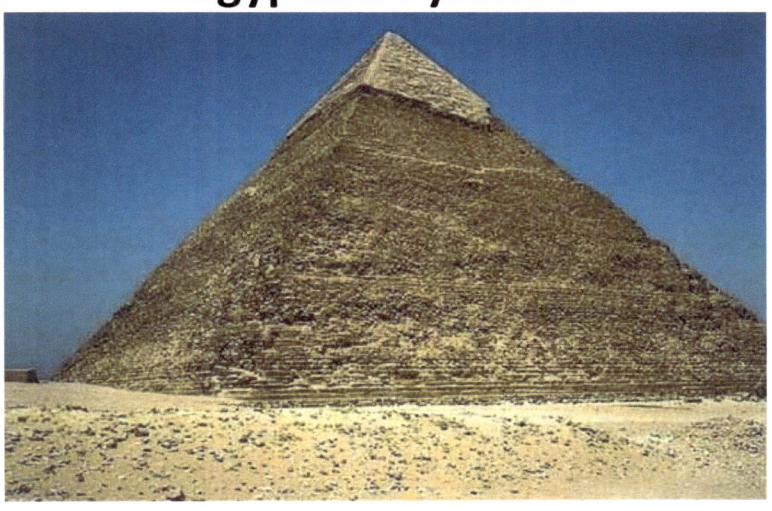

The Parthenon

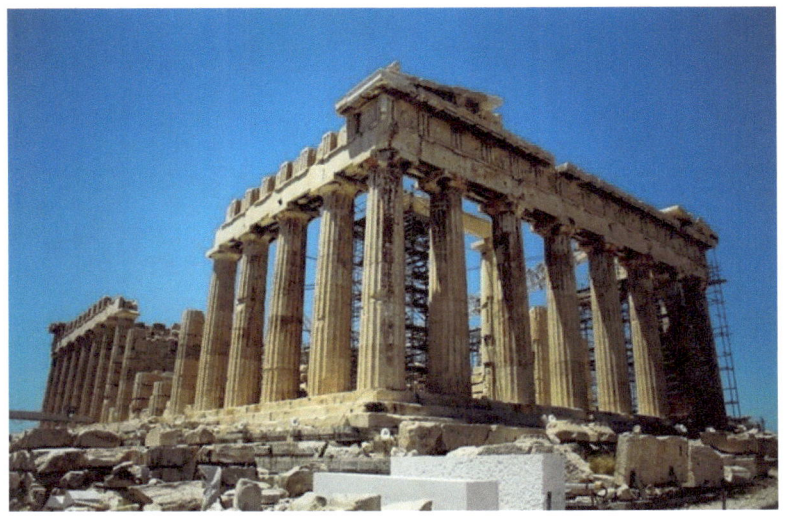

Writing is considered a form of art but unfortunately, some people can't read. In the United States today, 15% of the people can't read, and 21% of the adult population read below the fifth grade level. These numbers are shocking, but true.

Parents often teach children to read and write before they go to school, but prehistoric people did not read or write. The first writing of language did not begin until 5000 years ago, and the Greek alphabet was not developed until 3000 years ago.

Even after writing started most people were not educated and could not read or write – scribes (clerks) did most of the writing.

Theater dates back to Greece 2500 years ago and included music, dance, and religious festivities.

Greek Theater Epidaurus

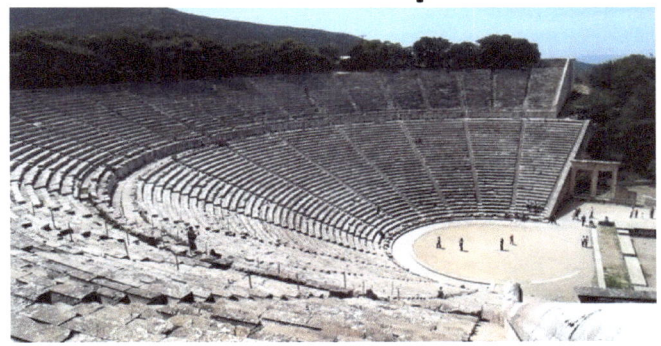

Renaissance Age Theater AD 1500

Photography is the youngest art form dating back to 1839 – 177 years ago. Artists had painted portraits, landscapes, and buildings for thousands of years before the Frenchman Louis Daguerre invented photography in 1839. George Eastman invented the Kodak Brownie camera in 1902 and photography became popular.

Louis Daguerre

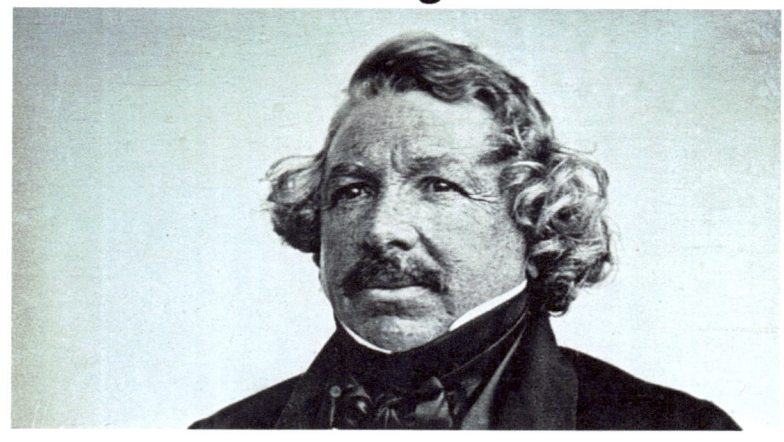

George Eastman

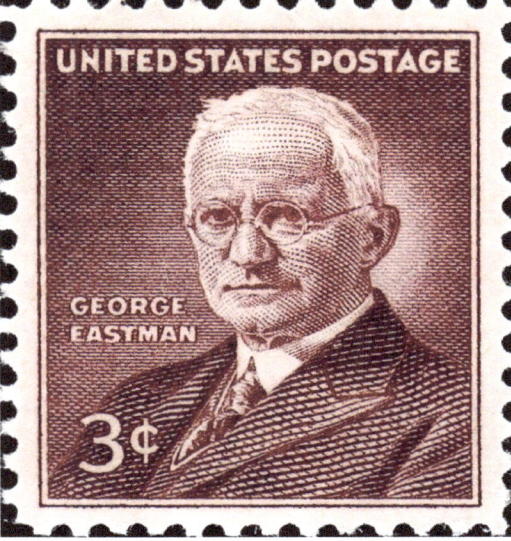

Kodak Brownie Camera

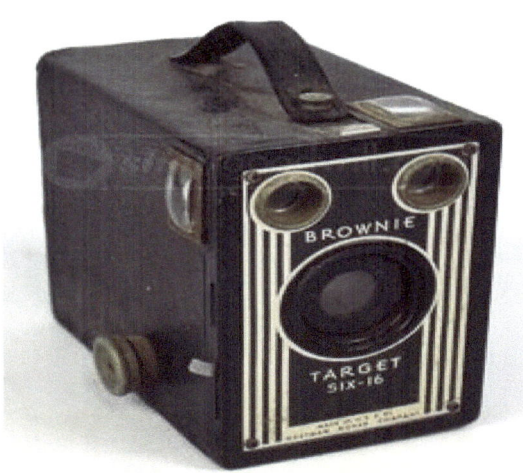

FAMOUS PHOTOGRAPHS

The Beatles

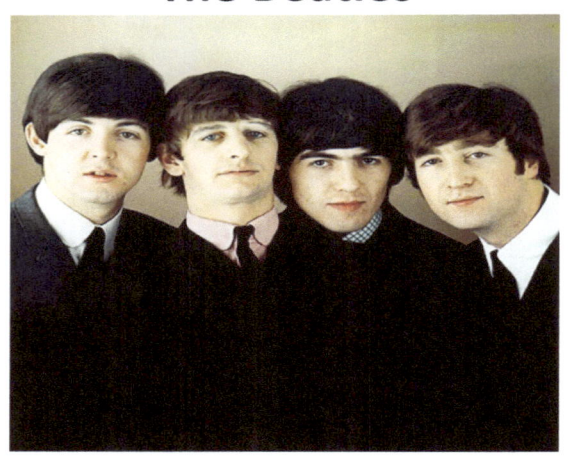

The Fallen Soldier

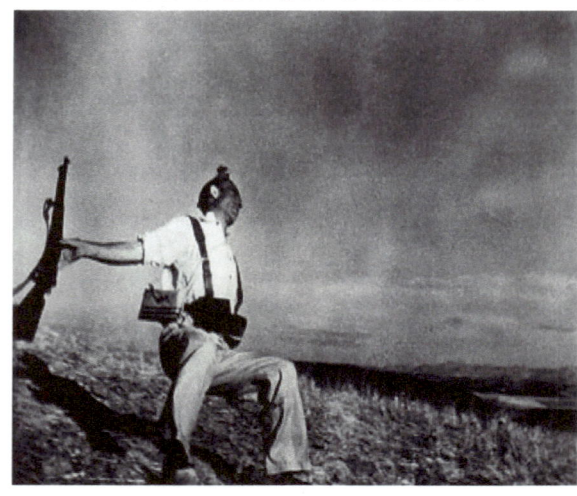

Migrant Mother

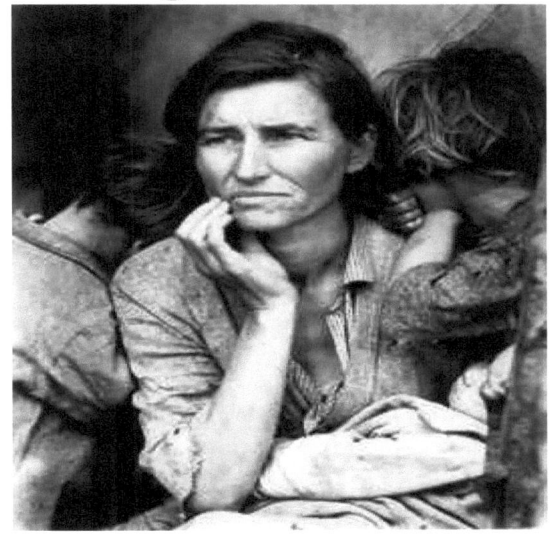

VJ Day

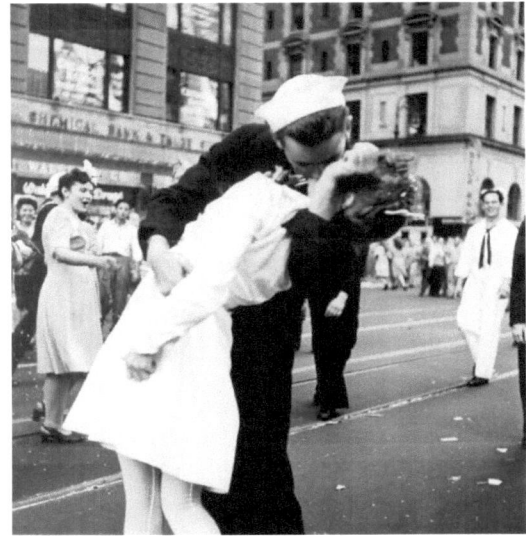

Art mirrors history and there were several art movements over the past centuries. Three of the most popular were the Renaissance Age, the age of Impressionism, and the Post-Impressionist Age.

The Renaissance Age began in 1400 and lasted until 1650, and two of the most famous artists lived in the era. Leonardo da Vinci is rated as the best artist in history and his *Mona Lisa* is the best painting of all time. Michelangelo is the fourth best artist and the *Creation of Adam* is the third best painting.

Leonardo da Vinci

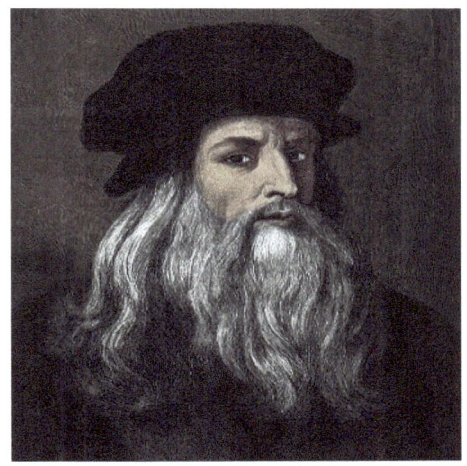

Mona Lisa

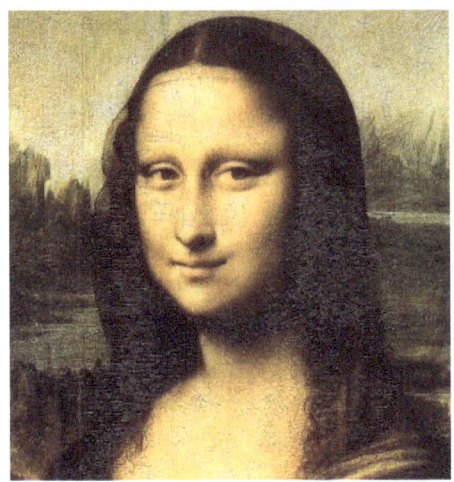

Michelangelo

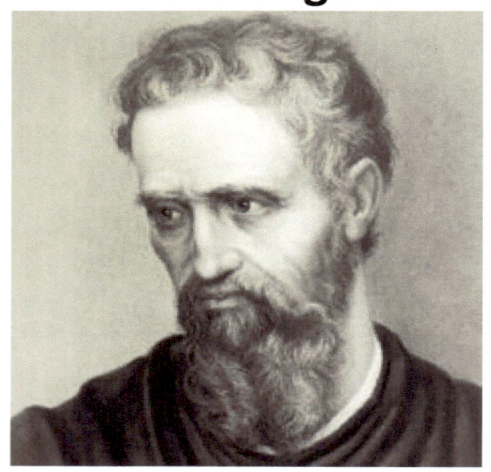

Creation of Adam

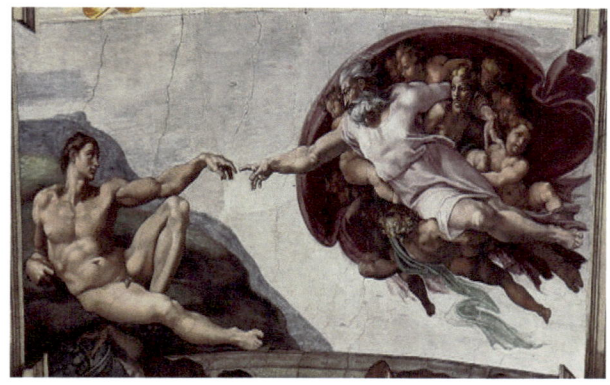

The Impressionist Age of 1870-1885 changed the art world. The artists painted scenes as the eye saw them in an instant. This unique art movement has become one of the most popular and the artistry has sold for millions.

Claude Monet is the fifth best artist in history and his *Water Lilies* sold for $80 million. August Renoir is rated as the eighth best artist and the painting *Moulin Galette* sold for $78 million.

Other impressionist artists such as Edward Degas, Alfred Sisley, Edouard Manet, and Gustave Caillebotte have become popular in recent years, and their artwork has also sold for millions.

Claude Monet

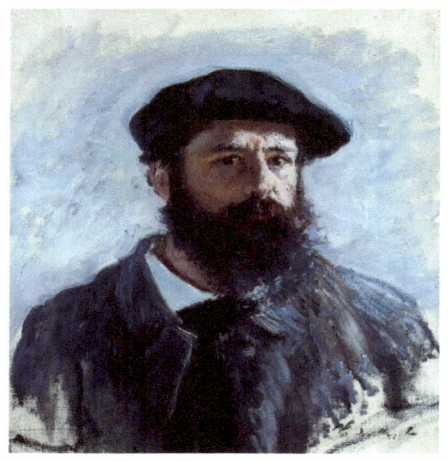

Water Lilies

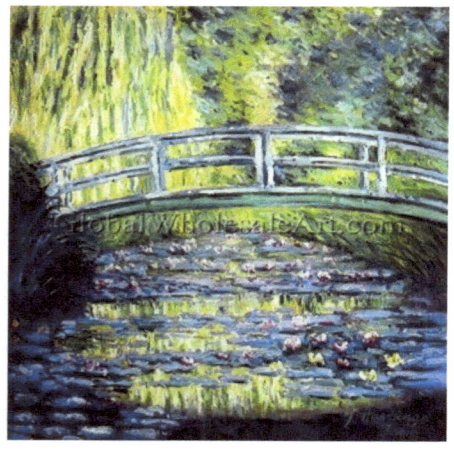

August Renoir

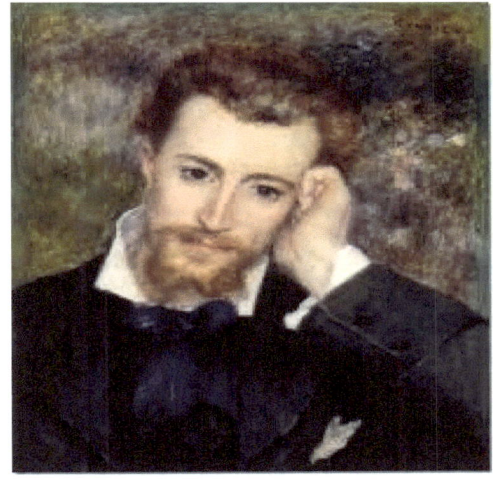

Moulin Galette

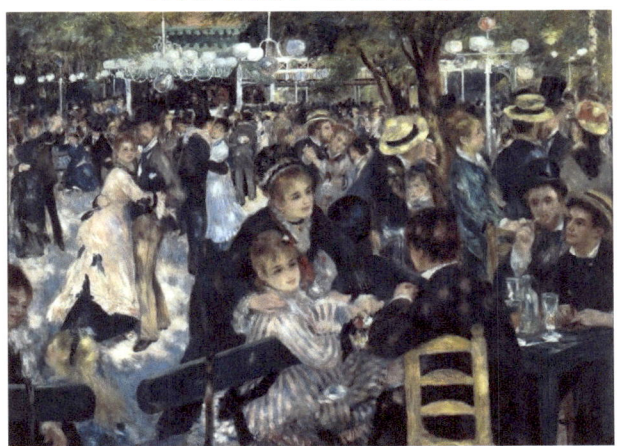

The Post-Impressionist Age began in 1885 and continued until 1900. The artists of this period used different styles from the impressionists.

There were several famous Post-Impressionist artists including Vincent van Gogh, Georges Seurat, Paul Gaugin, and Henri de Toulouse-Lautrec.

Vincent van Gogh is rated as the second best artist in history, and his famous painting *A Starry Night* is the second best painting .

Georges Seurat is known for his pointillism style of painting where tiny dots of color were used to present a picture. His *Island of the Grand Jatte* sold for $52 million in today's dollars.

Vincent van Gogh

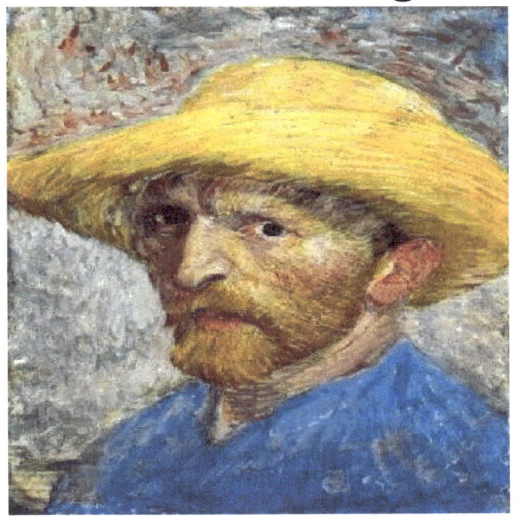

A Starry Night

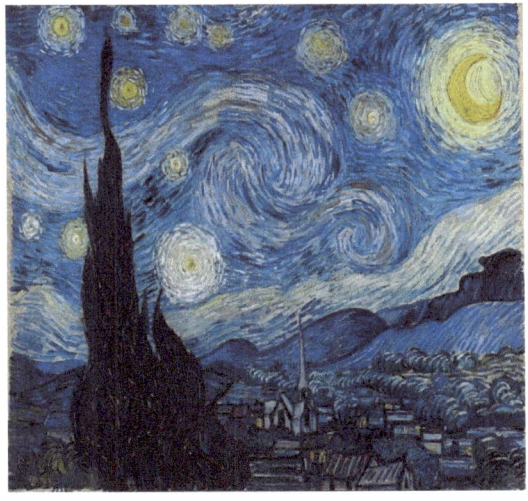

Georges Seurat

Island of the Grand Jatte

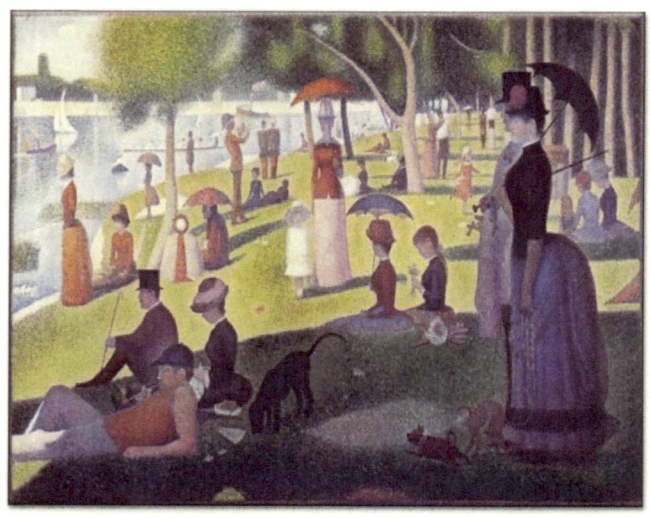

The unfortunate part of art is that most artists lived in poverty for most of their lives. A few artists like Pablo Picasso and Andy Warhol became wealthy with their art but they were in the minority. Vincent van Gogh is considered the second best artist in history, and his painting *A Starry Night* is rated the second best of all time, but he sold only one of his 913 paintings and 1100 drawings during his lifetime.

We should thank artists of the past for showing us their feelings and emotions in their artistry because art is truly a blessing.

BIBLIOGRAPHY

All Images are Public Domain

www.ingramcontent.com/pod-product-compliance
Lightning Source LLC
Chambersburg PA
CBHW040922180526
45159CB00002BA/569